ni Tàpies

SOUTHAMPTON
INSTITUTE

Antoni Tàpies
Works on Paper & Sculpture

Waddington Galleries
16 March – 16 April 2005

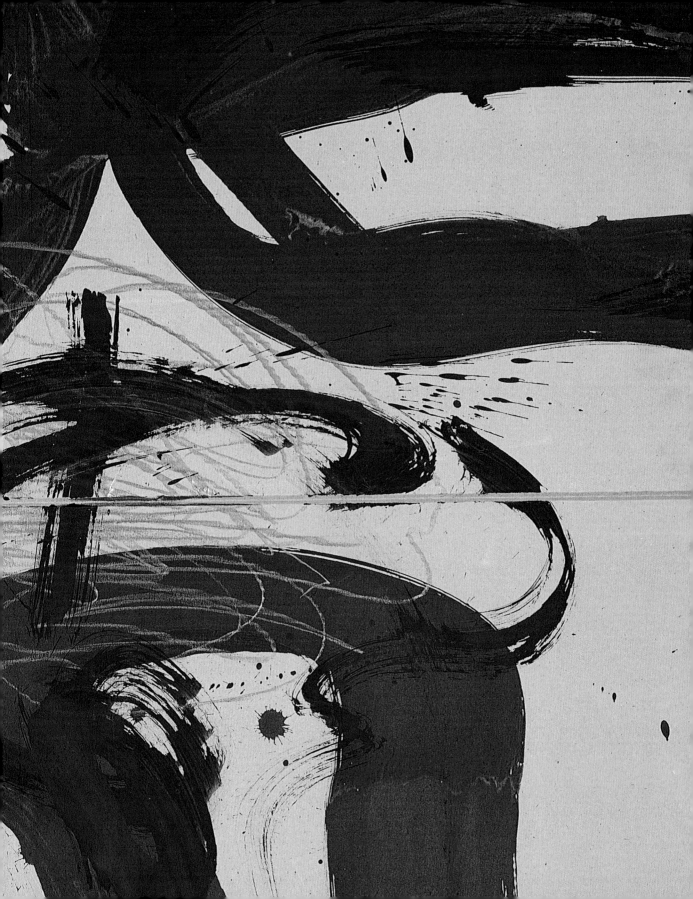

Antoni Tàpies
Works on Paper 1989–2004

Throughout a long career Antoni Tàpies has demonstrated that even the most negligible facts of human existence are infused with their own significance. We may not always be able to grasp this significance but somehow it matters that we have been alerted to it. It matters because Tàpies is one of a handful of artists living today who communicate a moral authority few would dare to challenge. (Jannis Kounellis and Cy Twombly, both of whom have affinities with Tàpies, are also among this elect). That authority comes from their absolute integrity as artists, an integrity that is born of fearlessness, a disregard for acceptance, and an instinctive need to challenge. Why, for example, should we accept that the ferociously pencilled scrawl in *Copa sobre vermell (Cup on red)*, cat. no. 16, has the status of a work of art when we would find it hard to explain why graffiti scrawled on a street wall does not? Tàpies might well step in here to remind us that graffiti, like a child's first pencil marks, has its own meaning, its own energy, its own sense of purpose, and therefore its own validity. Convincing us to look at things differently, and more openly, is one of the purposes of art, and the fact that it happens is a natural result of the artist's authority. In appropriating the inappropriate (graffiti, for example) Tàpies, like Kounellis or Twombly, makes us see the sense, and therefore the potential, of even the humblest forms of human expression.

One of the characteristics of graffiti is that it transgresses propriety. Art too has a history of transgressing what is considered appropriate, whether it is Manet's *Olympia* or Damien Hirst's glass vitrines of slaughtered flies and sliced carcasses. Transgression moves things along by continually prodding at easy assumptions and tired prejudices. The power behind the scribbled onslaught in *Copa sobre vermell (Cup on red),* carried out, one imagines, in one terrific surge of energy, is born of the same instinct that motivates the graffiti artist or the child drawing over a wall, a ruthless delight in self-expression. The ferocity of Tàpies's attack on the whiteness of the paper might be described as demented were it not for the quiet resolution that is found in the shape of the wine glass placed to one side, its containing shape somehow exerting calm in the face of the storm. In *Capsa negra (Black box)*, cat. no. 5, Tàpies sprays one image over another, an act of obliteration

opposite: **Tenalla** | Pliers (detail) cat no.11

and vandalism that looks deliberately aggressive (this could be the work of a young kid loose on the street with an aerosol can). The way in which artists like Dubuffet, Twombly and Tàpies have opened their art to graffiti is surely their way of lending credibility to the uncensored.

In *Quatre fletxes (Four arrows)*, cat. no. 27, the seemingly random pencil scribble is kept in check by the sculpted slab of paint on the right and the four arrows on the left flying to the centre in controlled formation. Tàpies has always been a master at negotiating the thin line between accident and design, between what is allowed to happen and what is made to happen. For instance, how much slippage is there between his initial idea for the bottle in *Sèrie Làtex XI. Ampolla (Latex series XI. Bottle)*, cat. no. 9, and how it finally turned out? Or, to put it another way, how far was its shape determined by the behaviour of the material itself? Latex has long been one of Tàpies's materials of choice, perhaps because more than other materials it carries with it a suggestion of unpredictability. Here, the unsteady shape of the bottle suggests an endless and mercurial process of shifting as though the object will never settle down into a final form. This deceptively soft and malleable material is perfectly suited to an artist who likes to leave things open-ended.

Many of the drawings play on the tension between accident and design, or rather, on our puzzlement about what has happened by chance and what has been engineered. *Collage del paper vermell (Collage of red paper)*, cat. no. 28, for instance, brings together the calculated grace of the calligrapher with the purpose-lessness of the doodle. The galloping thrust of the lines along the bottom edge of the paper has an animal energy that seems entirely calculated, whereas the lines brushed in above look more accidental. Yet, the way the lines are placed on the sheet in perfect balance one with the other has the same inevitability that is found in the work of the great Japanese calligraphers of the early seventeenth century. Take *Paper retallat sobre negre (Cut paper on black)*, cat. no. 15, in which a shaped piece of white cut-out paper laid down on black is spattered with blots and dabs and squiggles, the sort of marks one might find on an old piece of paper left lying about on the floor of a painter's

studio. To one side of this incoherence, and at first easily mistaken as part of it, is the artist's characteristic mark: a lower case 't' with the horizontal line cutting across the centre of the vertical. It may look modest and unassuming but the cross signals a moment of deliberation amidst the riotous mess, a small but sharp call to order. A particularly subtle example of the way Tàpies likes to play one force off against another can be seen in *Partitura II (Score II)*, cat. no. 18, in which a single broad sweep of black paint looms over three dancing notes in a musical score. They are marked 'fff' and 'p' (treble forte and piano) a range of volume that seems to echo the booming fortissimo of the black shape behind the quiet hum of the white paper. To the left, a cluster of smaller notes evokes a distant and fainter sound. The musical fragment introduces a lightness and playfulness to the drawing in the same way as the cacophony of dabs and smears illuminates *Paper retallat sobre negre (Cut paper on black)*, or the constellation of small star-shaped blots ('sparked' by the heavy thud of the hammer) brings a touch of humour to *T, taques i escrit (T, spots and writing)*, cat. no. 14.

In 1963, the American sculptor David Smith entitled one of his ink drawings, *I draw a great deal, because sculpture is such hard work*. Sculpture is hard work, and it is also slow. Painting can be too. Drawing, on the other hand, is rather like taking time off. It gives an artist the freedom to be spontaneous, to experiment, to leave a thought unfinished, or simply to play around. Very often this sense of release is reflected in the speed with which a drawing is executed. What is striking about the drawings in this exhibition, the earliest of which dates from 1989, is their pace. First comes the fierceness of the initial attack. One has no sense that Tàpies lingers over a sheet of paper wondering what to do or where to start. If there is a pause, it is the coiled up pause that comes a second or two before the strike. In *X grisa (Grey X)*, cat. no. 4, the slashing lines of the dark grey X are made with two sweeps of the arm, unhesitating and immediate, gestures that are followed by the equally fierce spatters of ink bottom right bursting on the paper like little firecrackers. At the top, a foot, an arrow and Tàpies's 't' bring the artist into the picture. In *T, taques i escrit (T, spots and writing)*, the hammer, consists of two formidably strong sweeps of the brush, creating a vivid

impression of the weight and power behind the arm wielding the blow. Indeed the 'force' with which the hammer lands on the paper creates not only the sparks around it but undermines the foundations of the accompanying script which shudders under the impact.

The initial attack is often followed up by a series of reflections, or afterthoughts (like the small aftershocks that follow an earthquake). In *Cercle rogenc (Reddish circle)*, cat. no. 22, for instance, these take the form of the small pencilled oval casually drawn inside the larger one, or the neat set of symbols arranged like a game in a box within a box. The foot and the arrow play a similar hieroglyphic role in *X grisa (Grey X)*, as the stencilled word and random letters do in *Matriu (Matrix)*, cat. no. 2. In *Paper amb collage I (Paper and collage I)*, cat. no. 13, the weight of the emphatic black slab of paint holding the centre is played off against the fragility of the folded and slightly crumpled white newspaper. Three dabs of black paint to the left hold everything in suspension. The drawings, then, seem to be done in two or more stages, but each bears the imprint of the initial creative onslaught that determines the character of the finished work. And that is where the real risk lies.

It is the first mark that is the most telling, and the most onerous. As the Italian sculptor Lucio Fontana once remarked about his slashed canvases: 'People think it's easy to make a cut or a hole. But it's not true. You have no idea how much stuff I throw away. The idea has to be realised with precision.' The last sentence holds the key. The reductive simplicity of some of the forms, like the dominating form in *Cercle rogenc (Reddish circle)*, for instance, or the great X in *X grisa (Grey X)*, can seem almost dauntingly brazen, but the authority with which they hold our attention depends on the precision of their placing, and of their execution. That precision does not come about by accident: it is the result of considerable mental preparation, and of long experience.

These are the works of an artist who is now in his early 80s. Their vitality is undiminished, but then why should it be otherwise? Age can sharpen rather than blunt the urge to paint. When Picasso reached his 80s, he remarked: 'I have

less and less time, and I have more and more to say'. Tàpies has always said what he has to say with force, directness and economy but one of the aspects of these late works on paper is the compulsive nature of the marks. It is as though the urgency to get ideas down on paper has given the unconscious a greater freedom. Perhaps this is why each drawing so gloriously preserves the essence of the primary sensation. This is not to say that the earlier work does not, but in the brazen directness of the handling, the rapidity of the execution, the confidence with which each mark lands on the paper, and indeed, the fury with which Tàpies wields his pencil and his brush, one is left in no doubt of the refusal to allow age to interfere with what needs to be said.

Sarah Whitfield

1
Fons de vernís | Varnish background
1989
paint and varnish on paper glued on canvas
$61^{7}_{8} \times 108$ in / $157 \times 274{\cdot}5$ cm

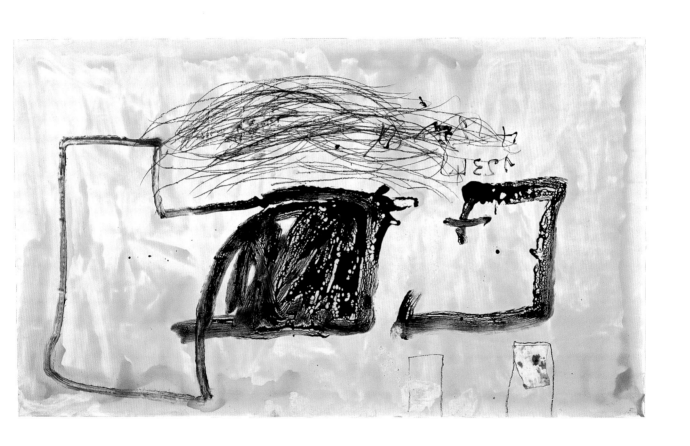

2
Matriu | Matrix
1991
paint and pencil on paper
$31 \times 41\frac{3}{4}$ in / 78.5×106 cm

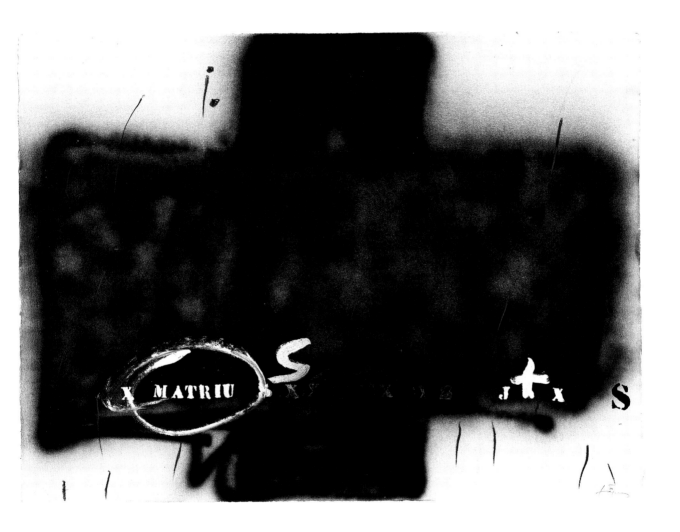

3
Franja negra central | Central black stripe
1991
paint and varnish on paper
47¼ × 31⅝ in / 120 × 80·5 cm

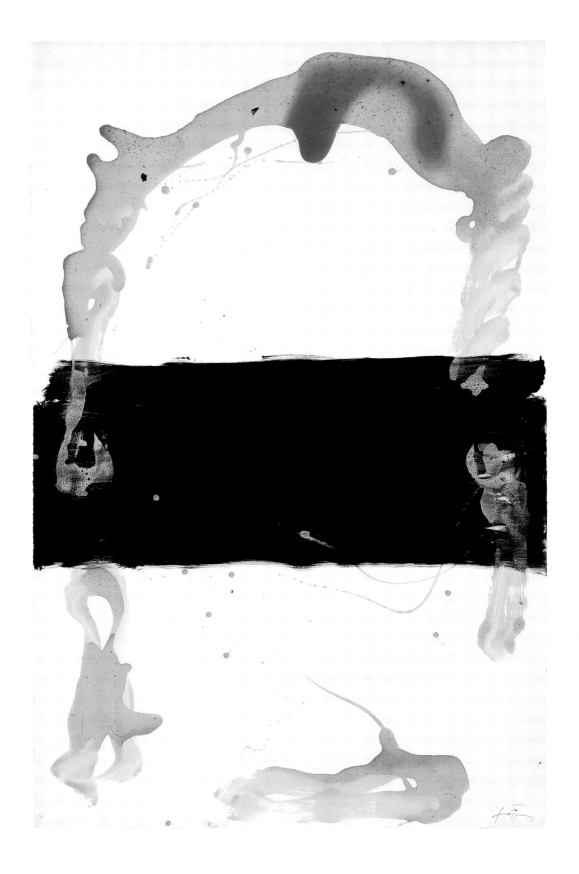

4
X grisa | Grey X
1996
paint on embossed paper
$34^5\!/_8 \times 50^1\!/_2$ in / 88×128.5 cm

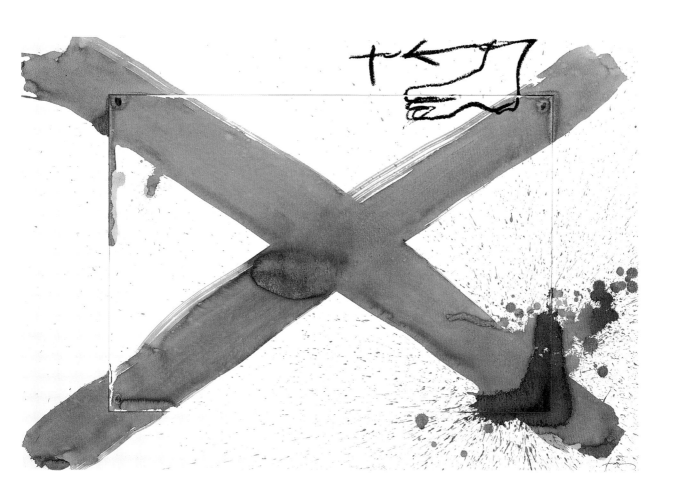

5
Capsa negra | Black box
1999
paint and pencil on paper
$48\frac{5}{8} \times 32\frac{5}{8}$ in / 123·5 × 83 cm

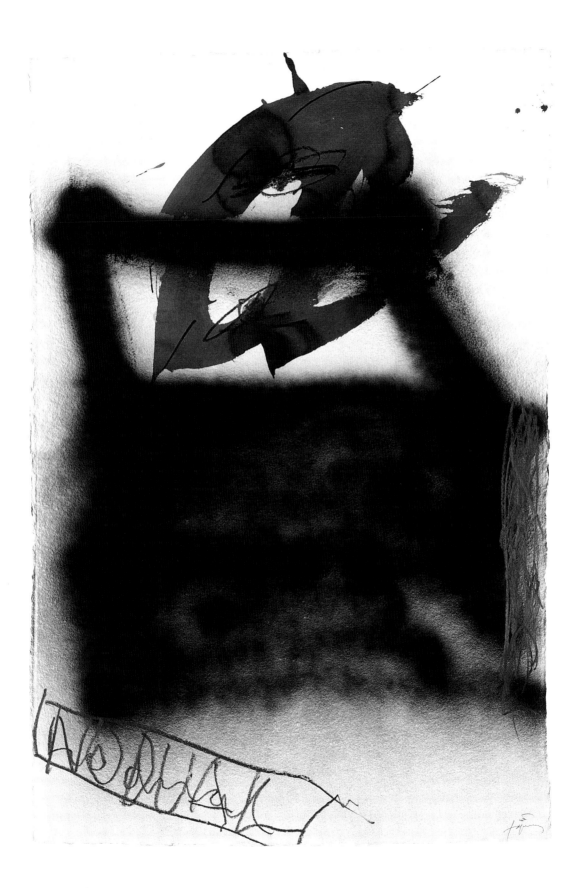

6
Braç dibuixat | Drawn arm
1999
paint and pencil on paper
$48^{7}_{8} \times 32^{5}_{8}$ in / 124 × 83 cm

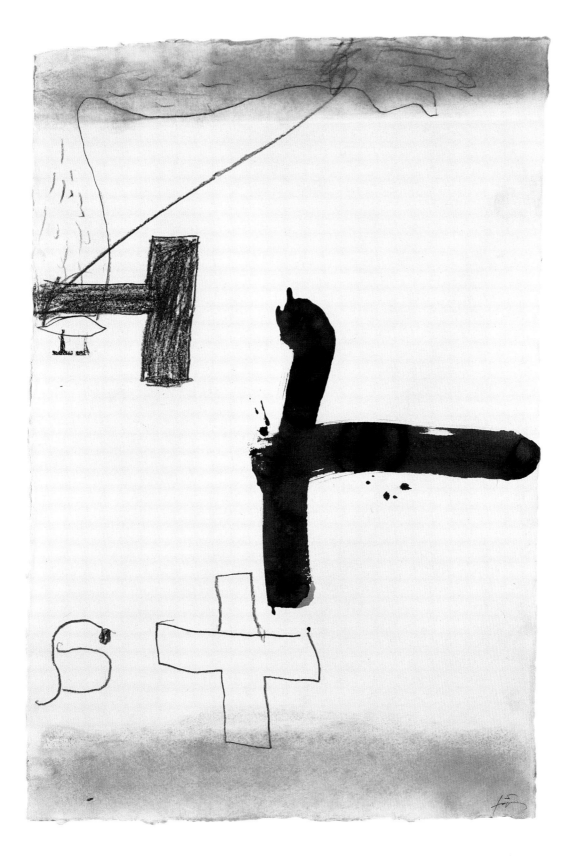

7
Quadrilàter negre | Black square
1999
paint and pencil on paper
48×63 in / 122×160 cm

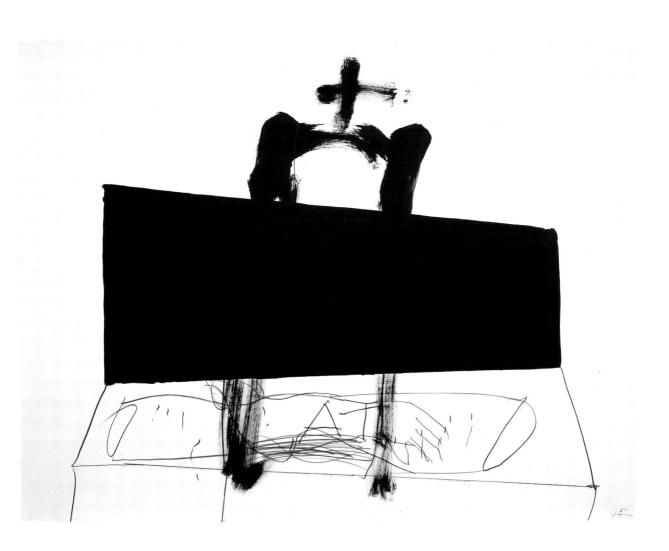

8
L'aspecte miraculós | The miraculous appearance
1999
paint and pencil on paper
$48^{7}_{8} \times 32^{7}_{8}$ in / $124 \times 83 \cdot 5$ cm

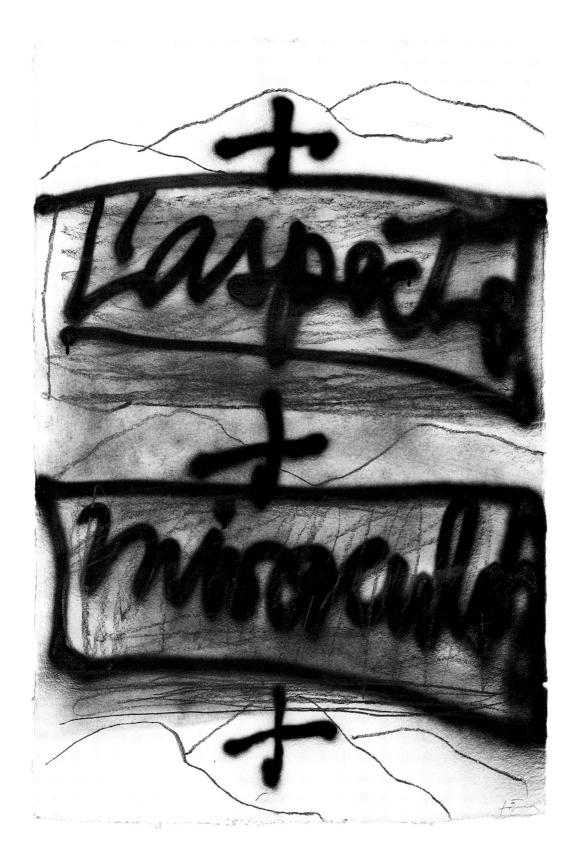

9
Sèrie Làtex XI. Ampolla | Latex series XI. Bottle
1999
paint, pencil and latex on paper
$30\frac{1}{4} \times 22\frac{7}{8}$ in / 77×58 cm

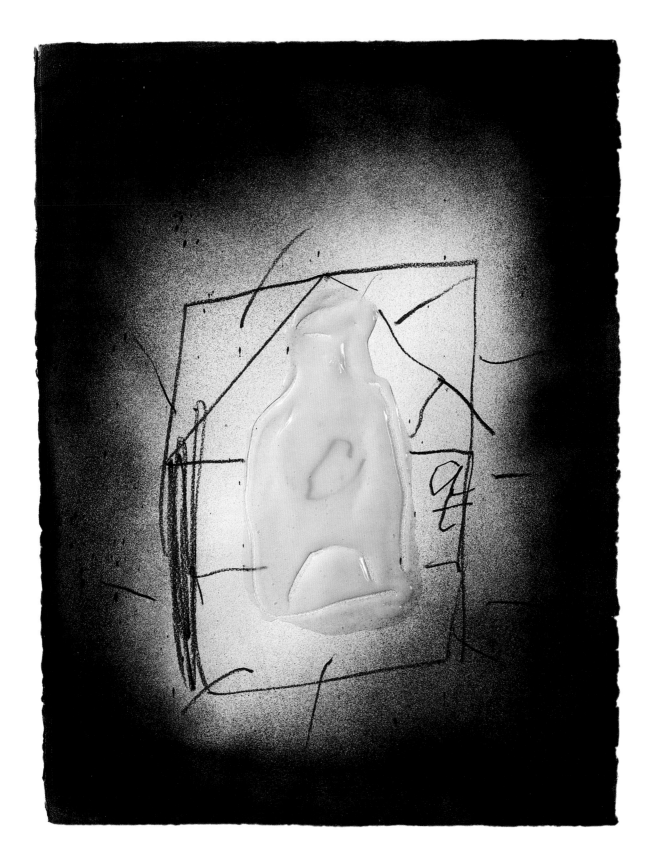

10
Signe V | Sign V
2001
paint on Chinese paper
$25\frac{1}{2} \times 38\frac{1}{2}$ in / 65×98 cm

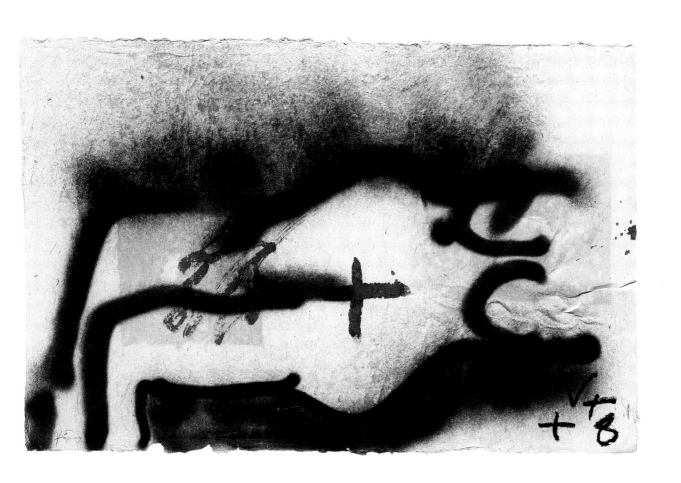

11
Tenalla | Pliers
2002
paint and pencil on cardboard glued on canvas .
$84\frac{1}{4} \times 44$ in / 214×112 cm

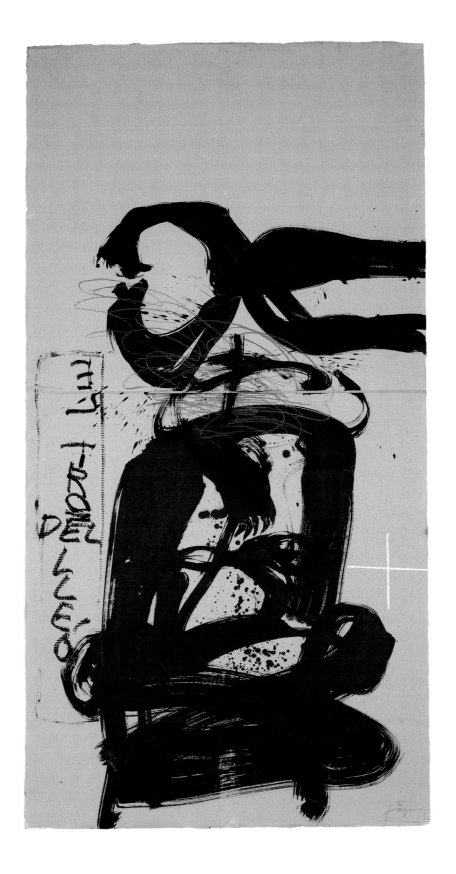

12
Dos peus | Two feet
2003
paint, pencil and collage on paper
31 × 42 in / 78·5 × 107 cm

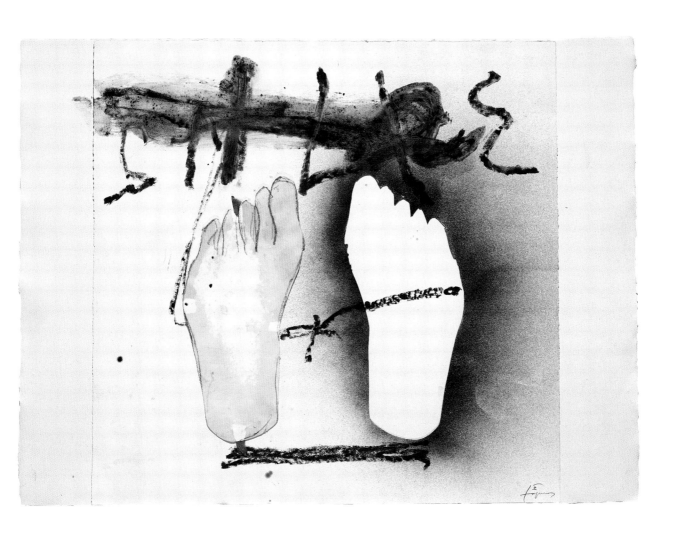

13
Paper amb collage I | Paper and collage I
2003
paint and collage on paper
$42\frac{1}{8} \times 31$ in / 107×78.5 cm

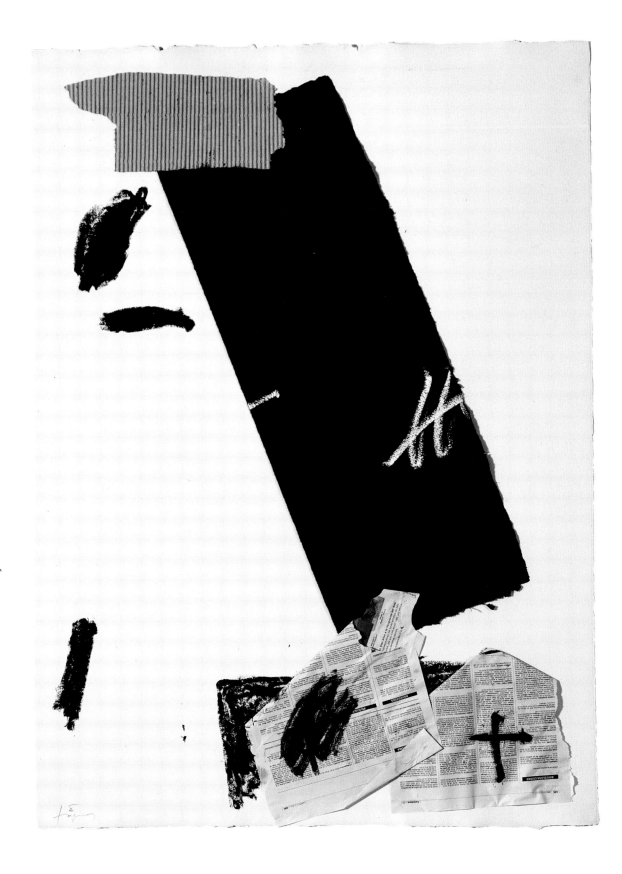

14
T, taques i escrit | T, spots and writing
2004
paint, ink and pencil on paper
$15^{1}_{8} \times 25^{1}_{4}$ in / 38.5×64 cm

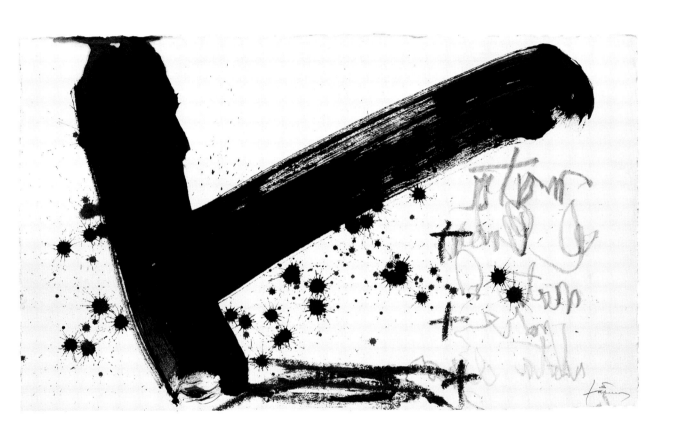

15
Paper retallat sobre negre | Cut paper on black
2004
paint and ball-point pen on paper glued on paper
22$\frac{1}{2}$×29$\frac{1}{2}$ in / 57×75 cm

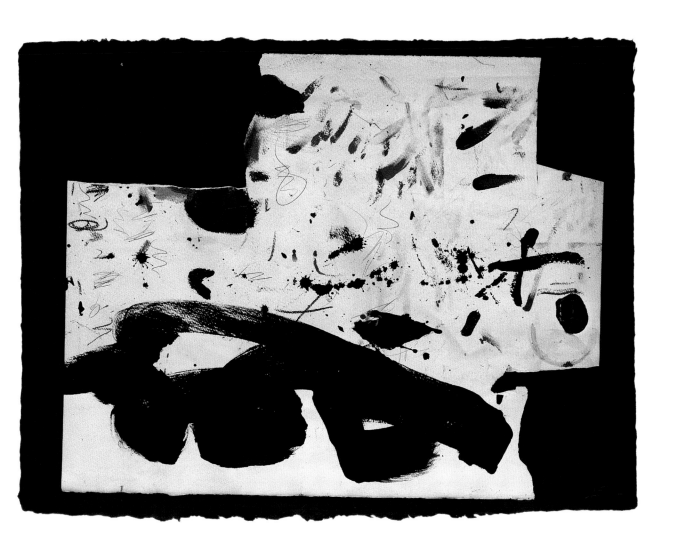

16
Copa sobre vermell | Cup on red
2004
paint and pencil on paper
$11\frac{1}{2} \times 15\frac{1}{2}$ in / 29×39.5 cm

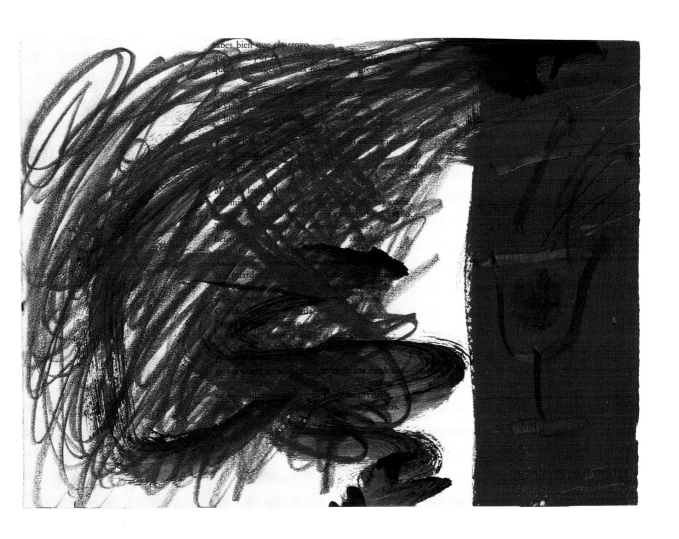

17
Creu encolada | Glued cross
2004
ink and collage on paper
$10 \times 17\frac{7}{8}$ in / $25 \times 45 \cdot 5$ cm

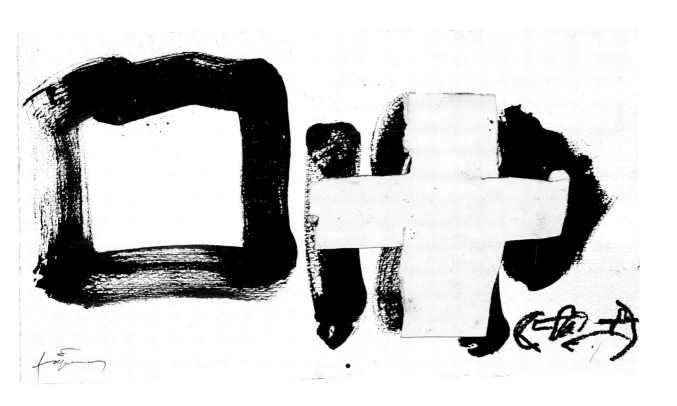

18
Partitura II | Score II
2004
paint and collage on paper
15¾×10 in / 40×25 cm

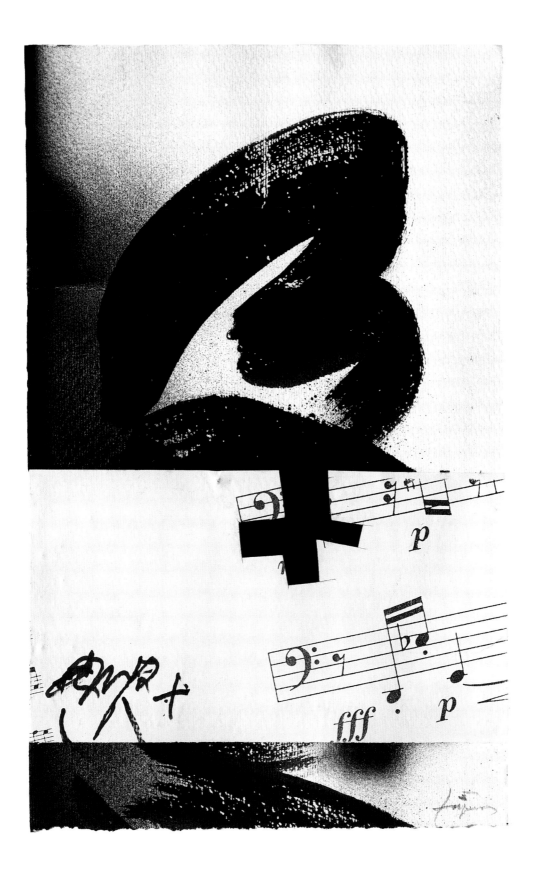

19
Collage del cartó | Collage of cardboard
2004
paint, pencil and varnish on cardboard glued on paper
$16\frac{1}{2} \times 23\frac{5}{8}$ in / 42×60 cm

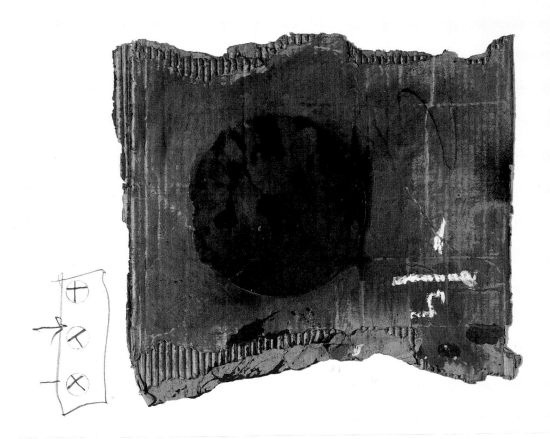

20
Franja negra i taques | Black stripe and spots
2004
paint, pencil and ball-point pen on paper
$16\frac{1}{2} \times 19\frac{5}{8}$ in / 42×50 cm

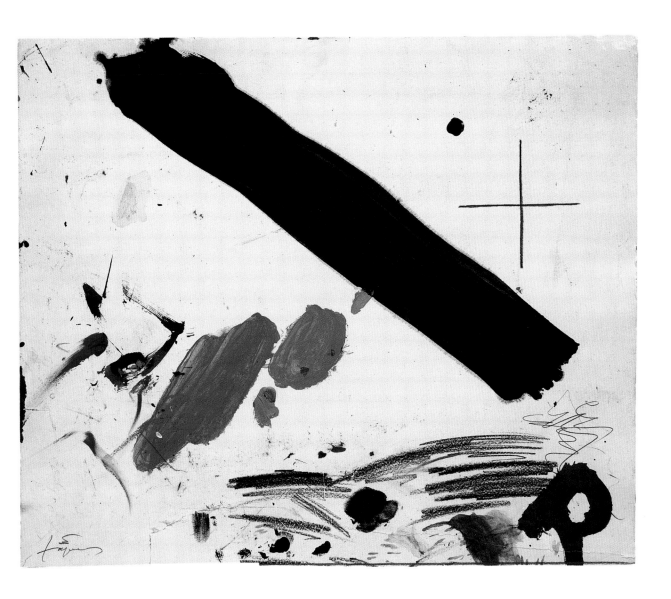

21
Collage i silueta | Collage and silhouette
2004
paint, pencil and collage on paper
$10\frac{5}{8} \times 10\frac{5}{8}$ in / 27×27 cm

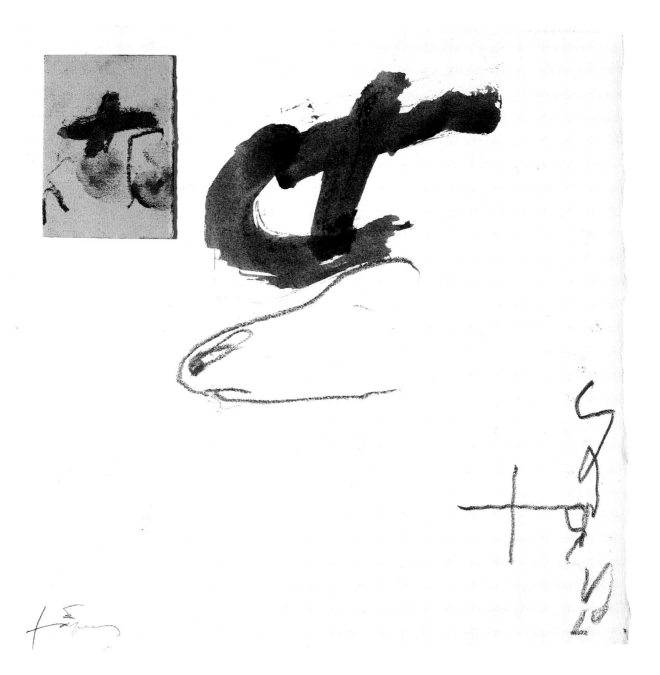

22
Cercle rogenc | Reddish circle
2004
paint, pencil and collage on paper
$19^{7}_{8} \times 27^{1}_{2}$ in / $50 \cdot 5 \times 70$ cm

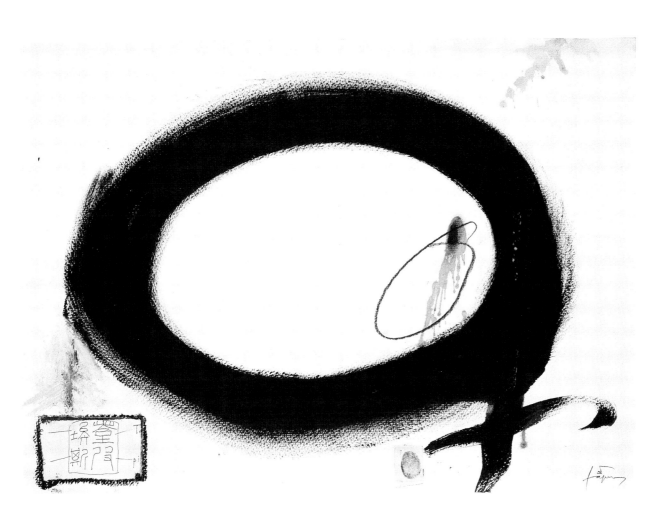

23
Paper d'estrassa I | Brown paper I
2004
paint, varnish and pencil on brown paper
$9^{7}_{8} \times 14^{3}_{8}$ in / 25×36.5 cm

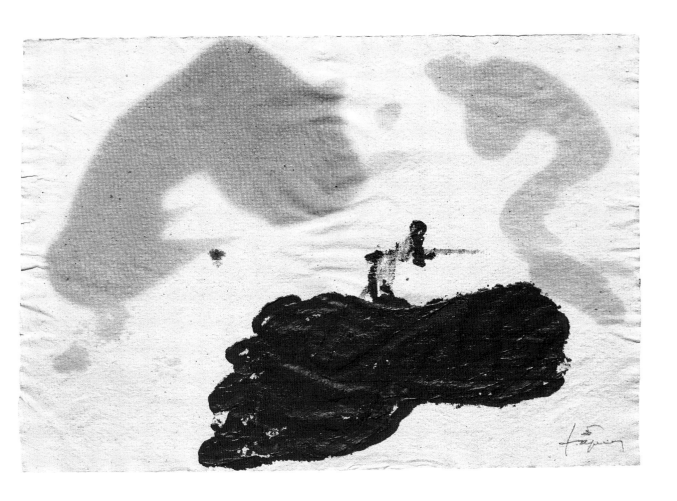

24
Taca i creu sobre cartó | Spot and cross on cardboard
2004
paint on cardboard
$9\frac{7}{8} \times 12\frac{3}{8}$ in / 25×31.5 cm

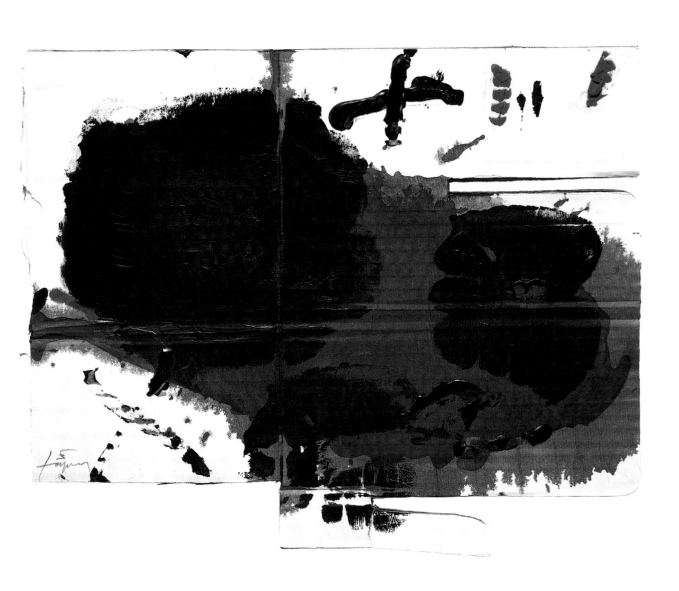

25
Esprai negre | Black spray
2004
paint on paper
10×12¼in / 25·5×31 cm

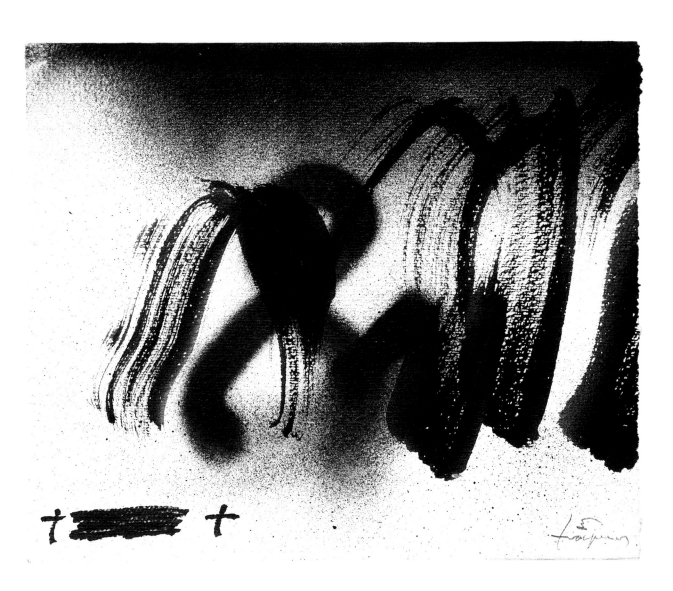

26
X retallada I | Cut X I
2004
paint and ink on paper
$19^1_4 \times 25^3_8$ in / $49 \times 64 \cdot 5$ cm

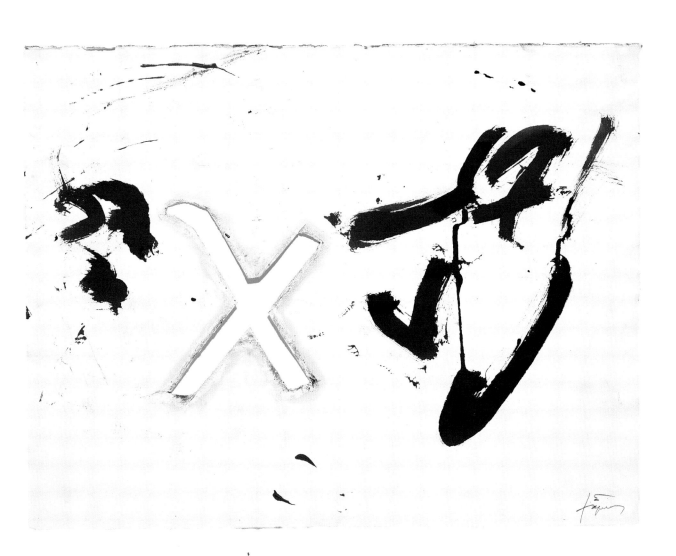

27
Quatre fletxes | Four arrows
2004
paint and pencil on cut paper, glued on paper
$25\frac{1}{2} \times 19\frac{7}{8}$ in / 65×50.5 cm

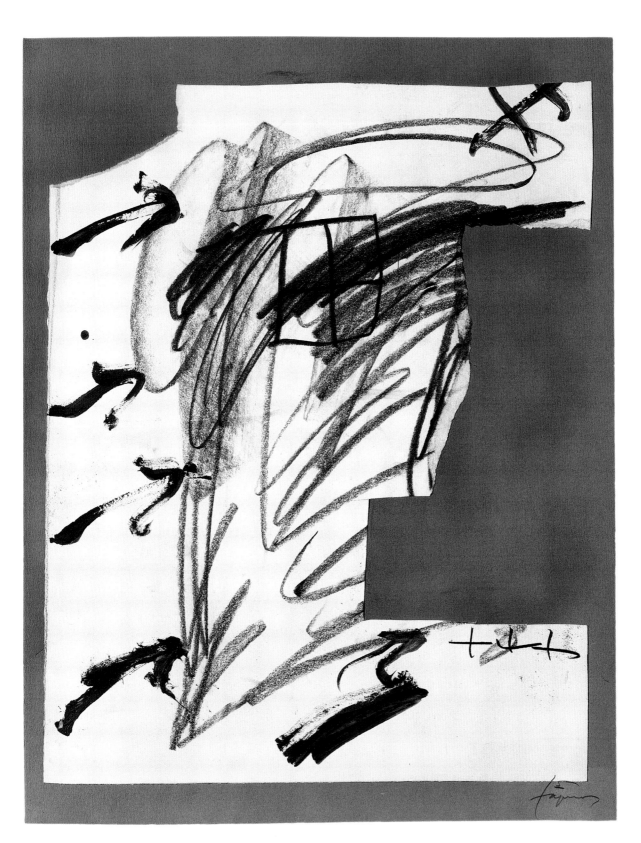

28
Collage del paper vermell | Collage of red paper
2004
paint, ink and collage on paper
$20^7_8 \times 25^3_4$ in / $53 \times 65 \cdot 5$ cm

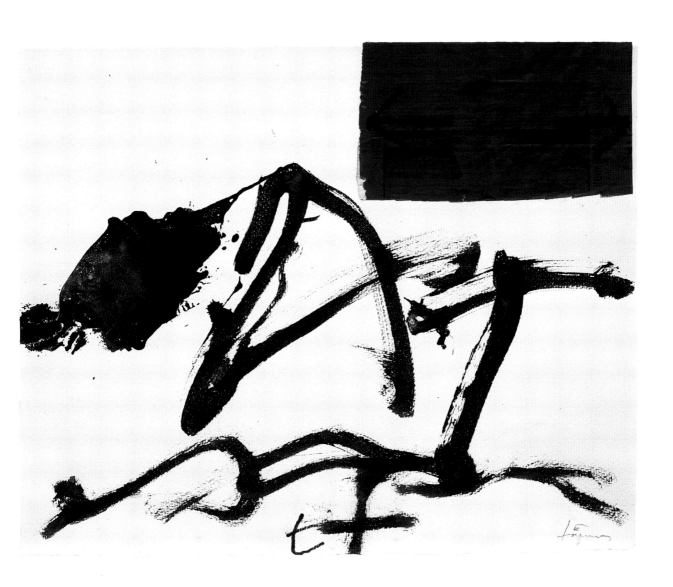

29
Llit obert | Open Bed
1986
enamel on fire clay
$38\frac{1}{2} \times 87 \times 38\frac{1}{2}$ in / $98 \times 221 \times 98$ cm

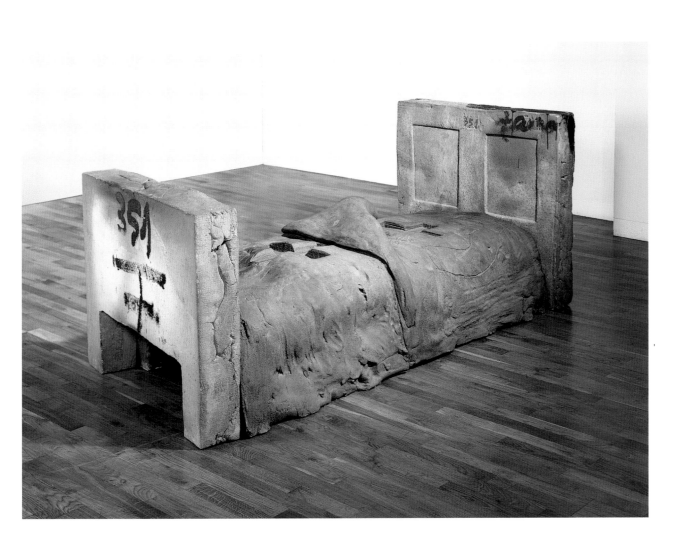

30
Cadira amb barra | Chair with bar
1988
enamel on fire clay
$41 \times 35^{3}_{4} \times 21^{5}_{8}$ in / $104 \times 91 \times 55$ cm

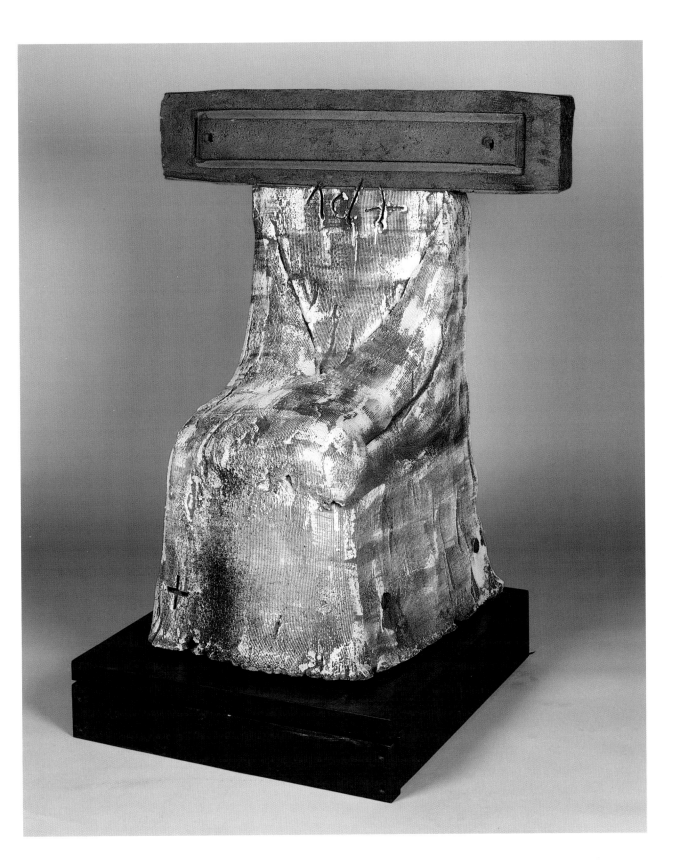

31
Campana petita | Small bell
1989–1993
painted bronze
$21\frac{1}{4} \times 21\frac{5}{8} \times 24\frac{1}{2}$ in / $54 \times 55 \times 62$ cm
cast no.6 from an edition of 6

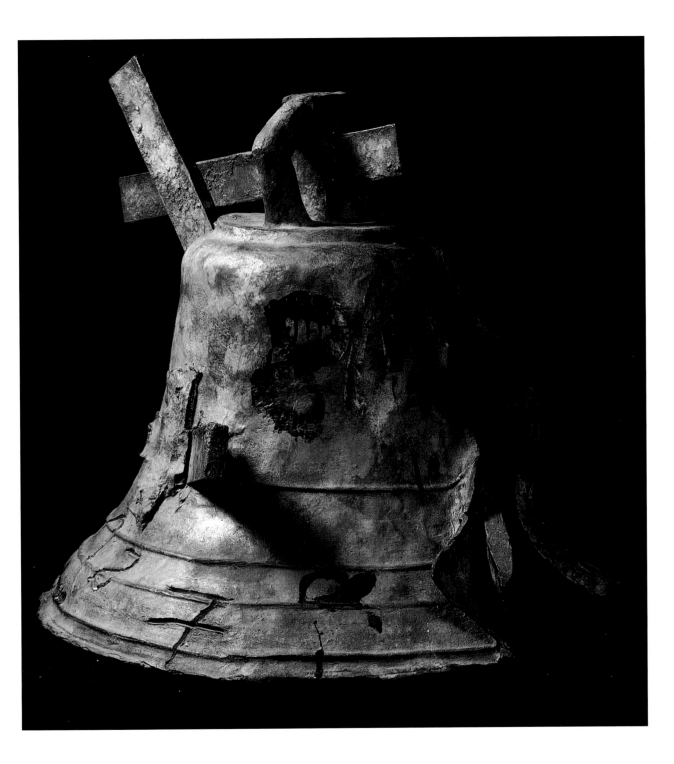

32
Llibre i coberts | Book and cutlery
1996
bronze and assemblage
$10^{5}/_{8} \times 27 \times 16^{1}/_{2}$ in / $27 \cdot 5 \times 70 \times 42$ cm
cast no.2 from an edition of 7

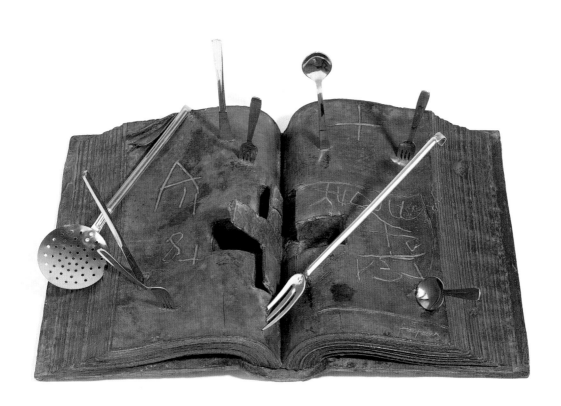

33
Esfera i cadena | Sphere and chain
1999
bronze and assemblage
$10^{7}_{8} \times 7^{1}_{2} \times 7^{7}_{8}$ in / 27·5 × 19 × 20 cm
cast no.5 from an edition of 6

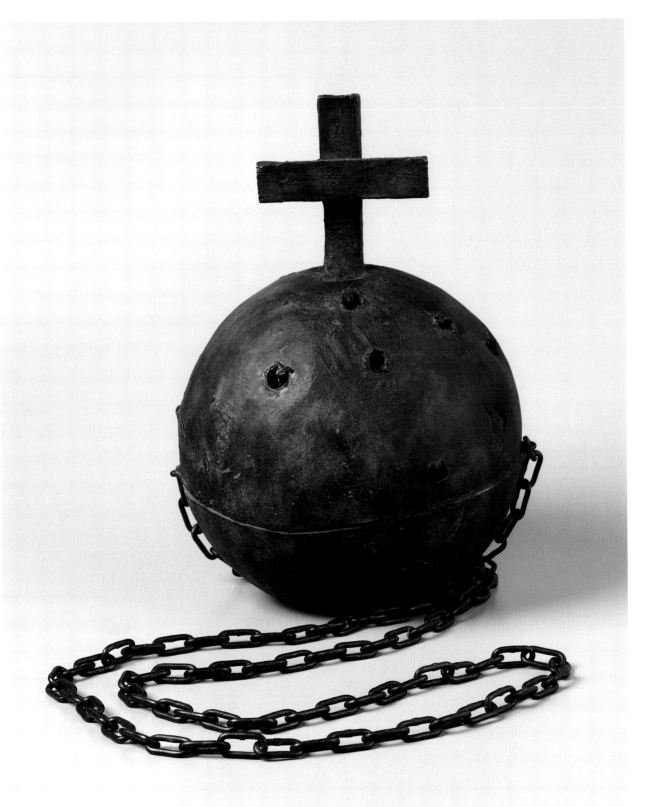

List of Works

1

Fons de vernís | Varnish background
1989
paint and varnish on paper glued on canvas
$61^7_8 \times 108$ in / $157 \times 274 \cdot 5$ cm

signed lower right "Tàpies"

Provenance
The artist

Exhibited
Tàpies. Celebració de la mel, organised by
the Fundació Antoni Tàpies, Barcelona,
Centro Atlántico de Arte Moderno, Las
Palmas, Gran Canaria, 19 July - 1 September
1991; touring to Pabellón Mudéjar, Seville, 12
March - 10 May 1992; Sala Rekalde, Bilbao, 6
October - 3 December 1992; Fundació Antoni
Tàpies, Barcelona, 22 June - 5 September
1993, catalogue no.77 (repro. in colour p.165)

Literature
Antoni Tàpies. unha antolóxica 1959-1995,
exhibition catalogue, Auditorio de Galicia,
Santiago de Compostela/Centro Cultural de
Belém, Lisbon, 1996 (repro. in b&w p.121)
(not exhibited)
*Tàpies - Obra Completa Volum 6è. 1986-
1990*, Anna Agustí, Fundació Antoni
Tàpies/Edicions Polígrafa, Barcelona, 2000,
catalogue no.5917, pp.363 & 549 (repro. in
b&w p.363)

2

Matriu | Matrix
1991
paint and pencil on paper
31×41^3_4 in / $78 \cdot 5 \times 106$ cm

signed lower right "Tàpies"

Provenance
The artist

Literature
*Tàpies - Obra Completa Volum 7è. 1991-
1997*, Anna Agustí, Fundació Antoni
Tàpies/Edicions Polígrafa, Barcelona, 2003,
catalogue no.6336, pp.122 & 566 (repro. in
b&w p.122)

3

Franja negra central | Central black
stripe
1991
paint and varnish on paper
$47^1_4 \times 31^5_8$ in / $120 \times 80 \cdot 5$ cm

signed lower right "Tàpies"

Provenance
The artist

Literature
*Tàpies - Obra Completa Volum 7è. 1991-
1997*, Anna Agustí, Fundació Antoni
Tàpies/Edicions Polígrafa, Barcelona, 2003,
catalogue no.6259, pp.88 & 565 (repro. in
b&w p.88)

4

X grisa | Grey X
1996
paint on embossed paper
$34^5_8 \times 50^1_2$ in / $88 \times 128 \cdot 5$ cm

signed lower right "Tàpies"

Provenance
The artist

Literature
*Tàpies - Obra Completa Volum 7è. 1991-
1997*, Anna Agustí, Fundació Antoni
Tàpies/Edicions Polígrafa, Barcelona, 2003,
catalogue no.6905, pp.434 & 579 (repro. in
b&w p.434)

5

Capsa negra | Black box
1999
paint and pencil on paper
$48^5_8 \times 32^5_8$ in / $123 \cdot 5 \times 83$ cm

signed lower right "Tàpies"

Provenance
The artist

6
Braç dibuixat | Drawn arm
1999
paint and pencil on paper
$48^7_8 \times 32^5_8$ in / 124 × 83 cm

signed lower right "Tàpies"

Provenance
The artist

Exhibited
Tàpies: Peintures, Galerie Lelong, Paris, 16
January - 1 March 2003, catalogue no.26
(repro. in colour p.51)

7
Quadrilàter negre | Black square
1999
paint and pencil on paper
48 × 63 in / 122 × 160 cm

signed lower right "Tàpies"

Provenance
The artist

Exhibited
Tàpies: Peintures, Galerie Lelong, Paris, 16
January - 1 March 2003, catalogue no.25
(repro. in colour p.53)

8
L'aspecte miraculós | The miraculous
appearance
1999
paint and pencil on paper
$48^7_8 \times 32^7_8$ in / 124 × 83·5 cm

signed lower right "Tàpies"

Provenance
The artist

9
Sèrie Làtex XI. Ampolla | Latex series
XI. Bottle
1999
paint, pencil and latex on paper
$30^1_4 \times 22^7_8$ in / 77 × 58 cm

signed lower right "Tàpies"

Provenance
The artist

10
Signe V | Sign V
2001
paint on Chinese paper
$25^1_2 \times 38^1_2$ in / 65 × 98 cm

signed lower left "Tàpies"

Provenance
The artist

11
Tenalla | Pliers
2002
paint and pencil on cardboard glued on
canvas
$84^1_4 \times 44$ in / 214 × 112 cm

signed lower right "Tàpies"

Provenance
The artist

Exhibited
Tàpies. tierras, Museo Nacional Centro de
Arte Reina Sofía, Madrid, 26 October 2004 -
17 January 2005, catalogue no.63 (repro. in
colour p.[183])

12
Dos peus | Two feet
2003
paint, pencil and collage on paper
31 × 42 in / 78·5 × 107 cm

signed lower right "Tàpies"

Provenance
The artist

13
Paper amb collage I | Paper and
collage I
2003
paint and collage on paper
$42^1_8 \times 31$ in / 107 × 78·5 cm

signed lower left "Tàpies"

Provenance
The artist

14
T, taques i escrit | T, spots and writing
2004
paint, ink and pencil on paper
$15^1_8 \times 25^1_4$ in / 38·5 × 64 cm

signed lower right "Tàpies"

Provenance
The artist

15
Paper retallat sobre negre | Cut
paper on black
2004
paint and ball-point pen on paper glued on
paper
$22^1_2 \times 29^1_2$ in / 57 × 75 cm

signed lower right "Tàpies"

Provenance
The artist

16

Copa sobre vermell | Cup on red
2004
paint and pencil on paper
$11^1_2 \times 15^1_2$ in / 29×39.5 cm

signed lower right "Tàpies"

Provenance
The artist

17

Creu encolada | Glued cross
2004
ink and collage on paper
10×17^7_8 in / 25×45.5 cm

signed lower left "Tàpies"

Provenance
The artist

18

Partitura II | Score II
2004
paint and collage on paper
$15^3_4 \times 10$ in / 40×25 cm

signed lower right "Tàpies"

Provenance
The artist

19

Collage del cartó | Collage of
cardboard
2004
paint, pencil and varnish on cardboard
glued on paper
$16^1_2 \times 23^5_8$ in / 42×60 cm

signed lower right "Tàpies"

Provenance
The artist

20

Franja negra i taques | Black stripe
and spots
2004
paint, pencil and ball-point pen on paper
$16^1_2 \times 19^5_8$ in / 42×50 cm

signed lower left "Tàpies"

Provenance
The artist

21

Collage i silueta | Collage and
silhouette
2004
paint, pencil and collage on paper
$10^5_8 \times 10^5_8$ in / 27×27 cm

signed lower left "Tàpies"

Provenance
The artist

22

Cercle rogenc | Reddish circle
2004
paint, pencil and collage on paper
$19^7_8 \times 27^1_2$ in / 50.5×70 cm

signed lower right "Tàpies"

Provenance
The artist

23

Paper d'estrassa I | Brown paper I
2004
paint, varnish and pencil on brown paper
$9^7_8 \times 14^3_8$ in / 25×36.5 cm

signed lower right "Tàpies"

Provenance
The artist

24

Taca i creu sobre cartó | Spot and
cross on cardboard
2004
paint on cardboard
$9^7_8 \times 12^3_8$ in / 25×31.5 cm

signed lower left "Tàpies"

Provenance
The artist

25

Esprai negre | Black spray
2004
paint on paper
10×12^1_4 in / 25.5×31 cm

signed lower right "Tàpies"

Provenance
The artist

26

X retallada I | Cut X I
2004
paint and ink on paper
$19^1_4 \times 25^3_8$ in / 49×64.5 cm

signed lower right "Tàpies"

Provenance
The artist

27

Quatre fletxes | Four arrows
2004
paint and pencil on cut paper, glued on paper
$25^1_2 \times 19^7_8$ in / 65×50.5 cm

signed lower right "Tàpies"

Provenance
The artist

28
Collage del paper vermell | Collage of
red paper
2004
paint, ink and collage on paper
20⁷⁄₈×25³⁄₄ in / 53×65·5 cm

signed lower right "Tàpies"

Provenance
The artist

29
Llit obert | Open Bed
1986
enamel on fire clay
38¹⁄₂×87×38¹⁄₂ in / 98×221×98 cm

signed on edge of bed cover "Tàpies";
produced in collaboration with Hans Spinner
at the studio of Galerie Lelong, Grasse

Provenance
The artist
Galerie Maeght Lelong, Paris
Galería Theo, Madrid
Private Collection, Madrid
Galería Elvira González, Madrid

Exhibited
Tàpies. Sculptures et reliefs muraux, Abbaye
de Montmajour, Arles, 6 July - 13 October
1986, catalogue no.19 (not repro.)
VII Salón de los 16, Museo Español de Arte
Contemporáneo, Madrid, May - June 1987
(repro. in colour in catalogue p.152)
Tàpies. tierras, Museo Nacional Centro de
Arte Reina Sofía, Madrid, 26 October 2004 -
17 January 2005, catalogue no.20 (repro. in
colour pp.[92-93] and b&w pp.[90-91])

Literature
*Tàpies - Obra Completa Volum 6è. 1986-
1990*, Anna Agustí, Fundació Antoni
Tàpies/Edicions Polígrafa, Barcelona, 2000,
catalogue no.5249, pp.69 & 534 (repro. in
b&w p.69)

30
Cadira amb barra | Chair with bar
1988
enamel on fire clay
41×35³⁄₄×21⁵⁄₈ in / 104×91×55 cm

produced in collaboration with Hans Spinner
at the studio of Galerie Lelong, Grasse

Provenance
The artist
Galerie Lelong, Paris

Exhibited
Tàpies, Galerie Lelong, New York, 16
February - 18 March 1989, catalogue no.40
(repro. in colour p.17)
Antoni Tàpies: Sculpture, Waddington
Galleries, London, 20 November - 21
December 1991, catalogue no.6 (repro. in
colour p.15)
*Antoni Tàpies: Bilder, Skulpturen,
Zeichnungen 1981-1997*, Kestner
Gesellschaft, Hannover, 6 December 1997 -
1 February 1998, catalogue no.43 (repro. in
colour) (image reversed)
Summer Exhibition, Royal Academy of Arts,
London, 29 May - 7 August 2000
Tàpies. tierras, Museo Nacional Centro de
Arte Reina Sofía, Madrid, 26 October 2004 -
17 January 2005, catalogue no.30 (repro. in
colour p.114) (image reversed)

Literature
*Tàpies - Obra Completa Volum 6è. 1986-
1990*, Anna Agustí, Fundació Antoni
Tàpies/Edicions Polígrafa, Barcelona, 2000,
catalogue no.5628, pp.234 & 542 (repro. in
b&w p.234)

31
Campana petita | Small bell
1989-1993
painted bronze
21¹⁄₄×21⁵⁄₈×24¹⁄₂ in / 54×55×62 cm
cast no.6 from an edition of 6

produced at Foneria Vilà, Tarragona

Provenance
The artist

Exhibited (various casts)
*Antoni Tàpies: Holzschnitt-Reihe "Suite
Erker", Arbeiten auf Papier, Terres
chamottées, Bronzen*, Erker-Galerie, St.
Gallen, 19 June - 30 October 1993 (repro. in
colour in catalogue p.51)
Tàpies en Silos, Abadía de Santo Domingo de
Silos, Burgos, Spain, April 2000 (repro. in
colour in catalogue p.29)

Literature
Bon dia, senyor Tàpies!, Mª Àngels Comella,
Romi Kirilova and Mercè Seix, Ediciones
Serres, Barcelona, 2001 (repro. in colour p.16)
*Tàpies - Obra Completa Volum 7è. 1991-
1997*, Anna Agustí, Fundació Antoni
Tàpies/Edicions Polígrafa, Barcelona, 2003,
catalogue no.6589, pp.250 & 572 (repro. in
b&w p.250)

32
Llibre i coberts | Book and cutlery
1996
bronze and assemblage
$10^5/8 \times 27 \times 16^1/2$ in / $27 \cdot 5 \times 70 \times 42$ cm
cast no.2 from an edition of 7

signed "Tàpies" and stamped with cast and
edition number "2/7"; produced by Barberí
Foneria Artística, Riudellots de la Selva,
Girona

Provenance
The artist
Waddington Galleries, London
Private Collection, London

Exhibited (various casts)
Antoni Tàpies: New Work, Waddington
Galleries, London, 18 October - 16 November
1996, catalogue no.4 (repro. in colour p.[17])
Antoni Tàpies, Galerie Lelong, Zurich, 22
November 1997 - 31 January 1998, catalogue
no.1 (repro. in colour)
*Tàpies. Materias, signos, evocaciones y
poemas*, Fundación Caja de Granada,
Granada, 5 February - 26 March 2002 (repro.
in colour in catalogue p.95)

Literature
Tàpies, exhibition catalogue, Museo Pecci,
Prato, 1997 (repro. in b&w p.179) (not
exhibited)
*Tàpies - Obra Completa Volum 7è. 1991-
1997*, Anna Agustí, Fundació Antoni
Tàpies/Edicions Polígrafa, Barcelona, 2003,
catalogue no.6936, pp.450 & 579 (repro. in
b&w p.450)

33
Esfera i cadena | Sphere and chain
1999
bronze and assemblage
$10^7/8 \times 7^1/2 \times 7^7/8$ in / $27 \cdot 5 \times 19 \times 20$ cm
cast no.5 from an edition of 6

signed "Tàpies" and stamped with cast and
edition number "5/6"; produced by Barberí
Foneria Artística, Riudellots de la Selva,
Girona

Provenance
The artist

Exhibited (various casts)
Antoni Tàpies: Recent Work, PaceWildenstein,
New York, 14 January - 12 February 2000
(repro. in colour p.21)
Tàpies, Galería Soledad Lorenzo, Madrid, 27
February - 30 March 2001 (repro. in colour in
catalogue p.42)

Biography

1923
Born in Barcelona, 13th December, into a liberal *catalanista* family.

1926–32
His early education in Barcelona is disrupted by poor health and frequent changes of school.

1934
Begins his secondary education. The Christmas issue of the magazine *D'ací i d'allà* publishes a feature on the artistic avant-garde which makes a lasting impression on him. Teaches himself to draw and paint. Catalan autonomy is declared.

1936
Outbreak of the Spanish Civil War.

1940
Enrols in the Instituto Menéndez y Pelayo and later returns to one of his former schools, the Escuelas Pías, where he finishes his secondary education.

1942
In the autumn, Tàpies develops a serious lung condition and enters the Puig d'Olena sanatorium in November. He stays there until June the following year reading extensively around German romanticism and Post-romanticism.

1943
Convalesces in Puigcerdà, continuing to study literature and making charcoal and pencil sketches based on reproductions of works by Holbein, Pisanello and Ingres.

1944–45
Briefly studies drawing at a school run by the painter Nolasc Valls but finds the teaching too academic. Begins a series of self-portrait drawings, a regular practice that continues until 1947. Begins his law studies at the University of Barcelona. Uses his sister's apartment on Carrer Diputació in Barcelona as a studio.

1946
He continues working in this studio on Carrer Diputació where he creates his first non-figurative works, mostly collages made of string, thread, scrap paper and cloth. Mixes with a group of young artists exhibiting at the Club Els Blaus, Sarrià, and meets the writers J.V. Foix and Joan Brossa, as well as members of the group Els Vuit.

1947
Meets Joan Prats, a prominent collector who introduces Tàpies to the work of Joan Miró. Continues to make collages while experimenting with *grattage* in his paintings. The cross, which will become a regular motif, makes its first appearance.

1948
Visits Miró's studio with an introduction by Prats through whom he becomes increasingly interested in the art of Paul Klee. Co-founder of the avant-garde magazine *Dau al Set*, which publishes the majority of the texts in Catalan. Participates in the *I Saló d'Octubre* held at the Galeries Laietanes, Barcelona.

1949
Participates in two important exhibitions: *Exposición antológica de arte contemporáneo*, Terrassa, and the *II Saló d'Octubre*, Barcelona. The poet João Cabral de Melo, the Brazilian consul in Barcelona, introduces Tàpies to Marxism.

1950
Participates in the *VII Salón de los Once* at the Galería Biosca, Madrid, which adopts a more radical line towards new art. Visits Salvador Dalí in Cadaqués. In October, obtains a grant from the French government to visit Paris where he hopes to find a gallery to show his work. The same month he holds his first solo exhibition at the Galeries Laietanes, Barcelona, which reflects his current interest in the work of the Surrealists. One of the paintings on show there is chosen for the *Pittsburgh International Exhibition of Contemporary Painting*. While living in Paris he begins *Història Natural (Natural History)*, a series of nineteen pen and ink drawings completed the following year.

1951

During his stay in Paris, visits Picasso at his studio in the rue des Grands-Augustins.

1952

Represented by five works at the *XXVI Biennale di Venezia*. Shows a number of the works made in Paris at the Galeries Laietanes, his second solo exhibition. Participates again in the *Pittsburgh International Exhibition of Contemporary Painting*.

1953

His first exhibition in the United States opens at the Marshall Field and Company Art Gallery, Chicago, but fails to find any buyers. Most of the works are shown again in October at the Martha Jackson Gallery, New York. During his visit he discovers the painting of the Abstract Expressionists in which he sees affinities with his own work.

1954

Moves away from figurative imagery in order to focus on materials and texture. Begins working with latex, which gives his work greater density and monumentality. Makes another trip to Paris to try and establish contact with commercial galleries. Marries Teresa Barba.

1955

Continuing his experiments with new materials, he begins to use a paste of varnish and marble dust impregnated with india ink and powdered pigments. Works on the theme of 'the wall' in which he explores the possibilities of painting as relief. Participates in a group exhibition *Phases de l'art contemporain*, organised by the poet and critic Édouard Jaguer. Takes part in the *III Bienal Hispanoamericana*, Barcelona, where he is awarded the Premio de la República de Colombia. Meets Michel Tapié, the author of the first monograph on his work, which is published the following year. With the help of Tapié he joins Rodolphe Stadler's gallery in Paris which opens in the autumn with a group show in which he participates.

1956

His first solo exhibition in Paris opens at the Galerie Stadler in January. Included in *Recent Abstract Painting* at the Whitworth Art Gallery, Manchester, along with leading American and European painters. Works on his first large assemblage, *Porta metàl.lica i violí (Metal shutter and violin)*, a new direction he does not immediately pursue, although the twin themes of the shutter and door become integral to the work. Makes his first trip to Italy.

1957

Organises an important exhibition of European and American abstract art, *Arte Otro*, at the Sala Gaspar, Barcelona, in which he brings together those artists Michel Tapié had grouped together around the idea of *art autre*: Appel, Burri, Dubuffet, Fautrier, de Kooning, Pollock, Tobey and Wols. Holds his first solo exhibition in Germany, at the Galerie Schmela, Düsseldorf.

1958

Travels to Milan where his first solo exhibition in Italy opens at the Galleria dell'Ariete. Meets Lucio Fontana. Fifteen works are shown at the Spanish pavilion at the *XXIX Biennale di Venezia* in a selection of primarily abstract art. Awarded the Grand Jury Prize of the Carnegie Institute, Pittsburgh. Marcel Duchamp, one of the judges, becomes a firm supporter of Tàpies's work in the United States.

1959

Following a successful solo exhibition at the Martha Jackson Gallery, New York, the Museum of Modern Art and the Solomon R. Guggenheim Museum each purchase a painting. Meets Robert Motherwell, Hans Hofmann and Franz Kline. Invited to show at *Documenta*, Kassel. Cardboard becomes an important new element in his paintings.

1960

Makes his first poster, on the occasion of the opening of the Museu d'Art Contemporani, Barcelona. In September, he participates in *New Forms-New Media,* a group exhibition with an international character held at the Martha Jackson Gallery.

1962

In February, the first retrospective of Tàpies's work opens at the Kestner-Gesellschaft, Hannover, organised by Werner Schmalenbach. This is followed by a second retrospective in March, at the Solomon R. Guggenheim Museum, New York, organised by Thomas Messer. Tàpies spends the summer in his recently acquired farmhouse in Campins, a small village at the foot of the Montseny mountain. In September, he works in St. Gallen on the mural for the library in the Handels-Hochschule.

1963

Moves into a new house and studio in the Carrer Saragossa, Barcelona, designed by J.A. Coderch. The new space enables him to work on a larger scale.

1964

In June exhibits eight large-format paintings at *Documenta*, Kassel. At the beginning of November a large exhibition of works on paper from 1946 to 1964 opens at the Sala Gaspar, Barcelona. A major monograph by Joan Teixidor is published on the occasion of the exhibition.

1965

In early June Tàpies visits London, where the Institute of Contemporary Arts is holding an exhibition of his work organised by Roland Penrose. During the summer he writes an important text on the influence of traditional painting on his own work, a text that he later publishes in an extended form as *La tradició i els seus enemics en l'art actual*.

1966

In March, along with around four hundred students and a large group of intellectuals, Tàpies takes part in a clandestine assembly of the Democratic Students' Union of the University of Barcelona: all the participants are arrested. Five years later, Tàpies's participation is judged to be a serious misdemeanour and he receives a fine.

1967

In November, attends the opening of his first solo exhibition at the Galerie Maeght, Paris, the start of a long relationship with the gallery with whom he has signed a contract. In addition to the exhibition catalogue, a special issue of *Derrière le miroir* is published with texts by Michel Tapié and Jacques Dupin.

1968

In March, attends the opening of a retrospective at the Museum des 20. Jahrhunderts, Vienna, organised by Werner Hofmann, which travels to Hamburg and Cologne. Designs the stained-glass windows at the chapel of the Convent of Zion in Valais. Makes his first tapestry, for the *Tapestry Biennial*, Lausanne.

1969

In February, a retrospective exhibition of his graphic work opens at the Kunstverein, Kassel, organised by Werner Schmalenbach, and with a catalogue introduction by Werner Hofmann. A film, *Antoni Tàpies* is produced by the Fondation Maeght, directed by Clovis Prevost.

1970

Household objects such as plates, newspapers, clothes, brooms and baskets, as well as natural materials such as straw, play an increasingly important role in his paintings. A collection of the artist's writings, *La pràctica de l'art*, is published in Barcelona. Attends a clandestine assembly in the monastery of Montserrat, near Barcelona, to protest against the so-called "Burgos Trial" in which a military court is judging opponents of the Franco dictatorship.

1971

Political themes find their way into his work, particularly in symbols of Catalan identity that also mark Tàpies's political resistance to the Franco regime.

1972

Awarded the Rubens Prize in Siegen, Germany, which he receives at the opening of a retrospective at the Städtische Galerie im Haus Seel.

1973–4

Tàpies is the subject of four retrospective exhibitions: at the Musée d'art Moderne de la Ville de Paris; the Louisiana Museum of Modern Art, Humlebaek, Denmark; the Nationalgalerie, Berlin; and the Hayward Gallery, London, organised by the Arts Council of Great Britain. In May 1974, Tàpies publishes a second collection of his writings under the title *L'art contra l'estètica*.

1976

A retrospective opens at the Fondation Maeght in Saint-Paul-de-Vence in July. This is followed in August by a retrospective at the Seibu Museum of Art, Tokyo. Designs a poster in support of a pro-democracy festival organised by the Congrés de Cultura Catalana and banned at the last moment by the authorities.

1977

A retrospective opens at the Albright-Knox Art Gallery, Buffalo, New York and travels to Chicago, San Antonio, Des Moines and Montreal. An exhibition of works on paper from 1944 to 1976 opens at the Kunsthalle Bremen and travels to Baden-Baden and Winterthur.

1978

The artist's autobiography, begun in 1966, is published under the title *Memòria personal: Fragments per a una autobiografia*. In the Spring, he attends the opening of an exhibition of his work at the Martha Jackson Gallery, New York, celebrating twenty-five years of collaboration between the artist and dealer.

1979

Experiments with a new form of relief involving objects covered with material which has been sprayed with paint. Awarded the Premi Ciutat de Barcelona and is elected honorary member of the Berlin Academy of the Arts. A retrospective opens at the Badischer Kunstverein, Karlsruhe and travels to Kiel and Linz.

1980

Tàpies is given his first retrospective in Spain, at the Museo Español de Arte Contemporáneo, Madrid, which includes more than two hundred and fifty works. In September, travels to Amsterdam for the opening of a retrospective at the Stedelijk Museum organised by Edy de Wilde.

1981

Awarded the Medalla de Oro de Bellas Artes, Spain's highest honour in the fine arts. He is invested doctor honoris causa by the Royal College of Art, London. Creates his first ceramic sculptures with the German ceramist, Hans Spinner. Commissioned by the Barcelona City Council to design a monument to Pablo Picasso. A large assemblage of furniture and pieces of cloth contained within a crystal cube and a fountain is unveiled in 1983.

1982

Publishes his third collection of writings under the title *La realitat com a art*. A retrospective opens at the Scuola di San Giovanni Evangelista, Venice, as part of the *XL Biennale di Venezia*. The Wolf Foundation of Jerusalem honour Chagall and Tàpies with their prize, the first artists to receive the award which previously had gone to scientists.

1983

Completes a large mosaic for the Plaça de Catalunya in Sant Boi de Llobregat, Barcelona, with the assistance of Joan Gardy Artigas. Awarded the Gold Medal of the Generalitat de Catalunya. Honoured by the French government as an Officier de l'Ordre des Arts et des Lettres. Makes a number of freestanding ceramic sculptures of furniture, books, clothes and small objects with Hans Spinner at Artigas's studio in Gallifa. This collaboration continues over the next five years.

1984

Awarded Rembrandt Prize by the Johann Wolfgang von Goethe Foundation, Basel. Receives the V Peace Prize from the United Nations Association in Spain. Constitutes the Fundació Antoni Tàpies in Barcelona.

1985
Publishes a new collection of writings titled *Per un art modern i progressista*. Awarded the Prix National de Peinture by the French government, and elected a member of the Royal Academy of Fine Arts, Stockholm.

1986
An anthological exhibition organised by Rudi Fuchs opens at the Wiener Künstlerhaus in Vienna, and travels to Eindhoven.

1987
The city of Barcelona hands over the Casa Montaner i Simó, a Modernist building by Lluís Domènech i Montaner to the Fundació Antoni Tàpies. Tàpies shows his first bronze sculptures, casts of manipulated household objects, at the Galeria Carles Taché, Barcelona.

1988
He is invested doctor honoris causa by the University of Barcelona. The Musée Cantini, Marseille, holds an exhibition selected from the artist's own collection of his work. Publication of *Tàpies. Obra completa 1943-1960*, first volume of the *catalogue raisonné* of the artist's work by Anna Agustí.

1989
Appointed honorary member of the Wiener Künstlerhaus, Vienna. Elected honorary member of the Real Academia de Bellas Artes de San Fernando, Madrid. A retrospective opens at the Kunstsammlung Nordrhein-Westfalen, Düsseldorf, organised by Werner Schmalenbach.

1990
Unveiling in February of the monumental aluminium and wire sculpture *Núvol i cadira (Cloud and chair)* made in collaboration with Pere Casanovas, on top of the headquarters of the Fundació Antoni Tàpies. Tàpies donates three hundred and eleven works to the Foundation.

1991
Tàpies is commissioned to create a monumental sculpture for the new Museu Nacional d'Art de Catalunya: his projected sculpture of a giant sock causes considerable controversy.

1992
Appointed honorary member of the Royal Academy of Arts, London, and of the American Academy of Arts and Sciences, Cambridge, Massachusetts. Creates a large mural for the Pabellón de Cataluña at the Exposición Universal, Seville, and a ceramic mural for the façade of the Musée de Céret, France.

1993
Together with Cristina Iglesias, Tàpies is chosen to represent Spain at the *XLV Biennale di Venezia* and his installation *Rinzen* wins the Leone d'Oro. UNESCO awards him the Picasso medal.

1994
A retrospective at the Galerie nationale du Jeu de Paume, Paris.

1995
A major retrospective at The Solomon R. Guggenheim Museum, New York. Tàpies is made a foreign associate member of the Académie des Beaux-Arts de l'Institut de France, Paris. An exhibition of his graphic work is held at the Museo de la Casa de la Moneda, Madrid. The Catalan Government awards him the National Visual Arts Prize.

1996
A major retrospective tours museums in Japan. Presented with the Cross of the Order of Santiago by the President of the Portuguese Republic in Lisbon.

1997
Contributes to a forum on intolerance at the Académie Universelle des Cultures, Paris, with a paper titled 'Art between despotism and anarchy'. Retrospective at Museo Pecci, Prato. Presented with the Gold Medal by the University of Oporto. An exhibition of works from 1981 to 1997 opens at Kestner Gesellschaft, Hannover and travels to Krems, Austria.

1998
An exhibition that spans over fifty years of his work on paper and cardboard is held at the Fundació Antoni Tàpies.

1999
Tàpies's *L'art i els seus llocs* is published as well as a re-edition of *Tàpies*, a complete collection of Juan Eduardo Cirlot's articles and writings on the artist.

2000
A retrospective at the Museo Nacional Centro de Arte Reina Sofía, Madrid. Takes part in the exhibition *Encounters. New Art from Old* at the National Gallery, London.

2002
Receives the Premio Nacional de Grabado y Arte Gráfico awarded by the Calcografía Nacional and the Real Academia de Bellas Artes de San Fernando, Madrid.

2003
Antoni Tàpies. Cos I llenguatge, organised by the Fundació Antoni Tàpies and the Diputació de Barcelona, begins a tour around different towns in Catalonia. The President of the French Republic appoints him to the rank of Commander in the Order of the Legion of Honour. *Tàpies. Werke auf Papier 1943–2003* opens in the Kunsthalle in Emden, Germany.

2004
The Museu d'Art Contemporani de Barcelona (MACBA) presents the exhibition *Antoni Tàpies. Retrospectiva*, for which the book *Tàpies en perspectiva* is published and which subsequently travels to Mexico (Museo de Arte de Zapopán). He attends the presentation of the documentary *T de Tàpies*, directed by Carolina Tubau and produced by Televisió de Catalunya. *Antoni Tàpies. Una arquitectura de lo visible* opens at the Fundación Marcelino Botín in Santander. In Madrid, *Tàpies. Tierras* opens at the Museo Nacional Centro de Arte Reina Sofía. He also has a solo exhibition in Barcelona.

This biography has been compiled with assistance from the Fundació Antoni Tàpies and from two main sources:

Tàpies: The Complete Works, Vols 1-7, ed. Anna Agustí, Fundació Antoni Tàpies/ Edicions Polígrafa, Barcelona, 1988 (Vol.1); 1990 (Vol.2); 1992 (Vol.3); 1996 (Vol.4); 1998 (Vol.5); 2000 (Vol.6); 2003 (Vol.7)

Tàpies, Solomon R. Guggenheim Museum, New York, 1995

Selected Public Collections

Albright-Knox Art Gallery, Buffalo, New York

Ars Nova Museum, Turku, Finland

Baltimore Museum of Art, Maryland

Carnegie Museum of Art, Pittsburgh

Centro Atlántico de Arte Moderno, Las Palmas

Centro Galego de Arte Contemporánea, Santiago de Compostela

Fondation Beyeler, Riehen, Switzerland

Fondation Maeght, Saint-Paul-de-Vence, France

FRAC Picardie, Amiens, France

FRAC Provence-Alpes-Côte d'Azur, Marseilles

Fundació Antoni Tàpies, Barcelona

Galerie für Moderne Kunst, Hannover

Galleria d'Arte Moderna, Ca' Pesaro, Venice

Galleria d'Arte Moderna, Bologna

Galleria Nazionale d'Arte Moderna, Rome

Göteborgs Konstmuseum, Göteborg, Sweden

Hirshhorn Museum & Sculpture Garden, Smithsonian Institution, Washington D.C.

Instituto di Tella, Buenos Aires

IVAM Centre Julio González, Valencia

Kiasma Museum of Contemporary Art, Helsinki

Kunsthalle Hamburg

Kunsthaus Zürich

Kunstmuseum Basel

Kunstmuseum Köln

Kunstmuseum St. Gallen, Switzerland

Kunstmuseum Winterthur, Switzerland

Kunstsammlung Nordrhein-Westfalen, Düsseldorf

Louisiana Museum of Modern Art, Humblebaek, Denmark

Marion Koogler McNay Art Museum, San Antonio, Texas

Moderna Museet, Stockholm

Musée Cantini, Marseilles

Musée d'Art Contemporain, Montréal

Musée d'Art Moderne de Céret

Musée d'Art Moderne de la Ville de Paris

Musée des Beaux-Arts, Lyon

Musée national d'art moderne, Centre Georges Pompidou, Paris

Museo de Arte Contemporáneo de Caracas Sofía Imber, Caracas

Museo de Arte Contemporáneo Internacional Rufino Tamayo, México D.F.

Museo de Arte Abstracto Español, Cuenca, Spain

Museo Nacional, Bogota

Museo Nacional de Bellas Artes, Buenos Aires

Museo Nacional Centro de Arte Reina Sofía, Madrid

Museu d'Art Contemporani, Barcelona

Museu de Arte Moderna, São Paulo

Museu Nacional d'Art de Catalunya, Barcelona

Museum Boijmans Van Beuningen, Rotterdam

Museum des 20. Jahrhunderts, Vienna

Museum Bochum-Kunstsammlung, Bochum

Museum Folkwang, Essen

Museum Ludwig, Cologne

Museum Moderner Kunst Stiftung Ludwig, Vienna

Museum of Contemporary Art, Los Angeles

Museum of Fine Arts, Houston, Texas

Museum of Modern Art, New York

National Gallery of Victoria, Melbourne

Nationalgalerie, Berlin

Reed College, Portland, Oregon

San Francisco Museum of Modern Art

Saison Museum of Art, Karuizawa, Nagano, Japan

Sammlung Essl, Vienna

Scottish National Gallery of Modern Art, Edinburgh

Seibu Museum of Art, Tokyo

Sintra Museu de Arte Moderna, Sintra, Portugal

Solomon R. Guggenheim Museum, New York

Sprengel Museum, Hannover

Staatsgalerie, Stuttgart

Stadtische Galerie im Stadelsches Kunstinstitut, Frankfurt am Main

Städtische Kunsthalle, Mannheim, Germany

Stedelijk Museum, Amsterdam

Sutai Pinacotheca, Osaka, Japan

Tate, London

University Art Museum, University of California, Berkeley

University of Michigan Museum of Art, Ann Arbor, Michigan

Van Abbemuseum, Eindhoven, The Netherlands

Walker Art Center, Minneapolis

Washington University Gallery of Art, St. Louis, Missouri

Wilhelm Lehmbruck Museum, Duisburg

Williams College Museum of Art, Williamstown, Massachusetts

Antoni Tàpies
Works on Paper & Sculpture
16 March – 16 April 2005

Waddington Galleries
11 Cork Street
London
W1S 3LT

Telephone + 44 20 7851 2200 / 020 7851 2200
Facsimile + 44 20 7734 4146 / 020 7734 4146
E-mail mail@waddington-galleries.com
Website www.waddington-galleries.com

Monday to Friday 10am – 6pm
Saturday 10am – 1.30pm

Photography by Gasull Fotografía, Barcelona and
Prudence Cuming Associates, London
Designed by Hoop Design, London
Printed by Dexter Graphics

Cover:
Paper amb collage I | Paper and collage I (detail) cat no.13

ISBN: 0-9548126-7-0